Thrust

David Zwirner Books

ekphrasis

Thrust
A Spasmodic Pictorial History of the Codpiece in Art
Michael Glover

For Ruth

If you are not kneeling in front of this piece,
you certainly should be.
—Paul Hodgson

Into the Thick of It: A Few Words to Introduce This Careful Unveiling of the Marvels of the Codpiece

The codpiece was invented in the Middle Ages as a rather visually un-arousing object of utility meant to deal with an embarrassing absence close to the midpoint of that poor, forked creature: man. A mere limp triangular flap of linen at first, the codpiece was intended to cover the drafty and revealing gap between the two separate pieces of men's stockings. Yes, like socks, men's stockings came in pairs: one stocking for the left leg, the other for the right. Little by little, the codpiece expanded in size, snarl, and just-look-at-me ambition.

By the sixteenth century, it had become not only an item of clothing but also a statement of high fashion. Codpieces were easily individualized and accessorized, and often made of the finest of decorated fabrics, complete with ribbons and bibbons and other bits of nonsense. In the middle of the century, Cosimo de' Medici, duke of Florence and Tuscany, and his entire army of handpicked German mercenaries, the *lanzichenecchi*, were strutting around the Piazza della Signoria in codpieces that had become more noticeable in terms of their size and colorfulness as well as more useful in ways other than bridging that scrotum-shriveler of a gap. What had started as a gesture of modesty, a means of concealing the male genitals, grew into a garment that drew attention to, mimicked, and even aggrandized them to a ridiculous degree.

What was it used for, then, other than to exaggerate and adorn the mighty male organ of generation? Well, as a pocket, for one thing. Or, stuffed with straw or horsehair, for shapeliness's sake, it could help protect the more beautiful outer surface of one's stockings against staining from smeary ointment used to treat syphilis. It had other functions too. It could be used to hang things from, as Thomas Lodge evidently observed in 1596: "His spectacles hang beating over his codpiece like the flag in the top of the maypole."[1] Or money could be deposited in the codpiece—you never quite knew how soon you might have to pay off an eager admirer. Even a kerchief could be tucked in there to facilitate some hasty mopping-up operation. And, oh yes, the codpiece sometimes served as a pincushion, because men's attire in the sixteenth century was often so complicated, with its folds and wrappings round, sweepings over, tuckings, and overlappings, that pins might come in handy.

Why so big though? There is one quite simple explanation for its size. As stockings, driven by the cruel dictates of men's fashion, got tighter and tighter, they became more and more rod-and-tackle constricting. The codpiece, roomier by comparison, gave some welcome relief from this overtight squeeze, when required.

This light-hearted examination of the gigantic history of the short-lived codpiece as depicted in various works of art (principally paintings from the sixteenth century, when the codpiece was at the height of its popularity

in France, Germany, England, and Italy) will also yank in François Rabelais, William Shakespeare, and a few raucous, rude, and irreverent scribblers who were much preoccupied by codpieces. Sadly for its admirers, the codpiece was fashionable for a mere half century or so, starting around 1540. Male braggadocio later assumed other forms, all equally ridiculous: the powdered wig, the raked-over ginger hairpiece, the Cuban heel, the "nude" trouser look. Indeed, men have tried it on in so many different ways throughout the sad and inglorious history of their untiring self-puffery.

The codpiece has experienced something of a comeback in our own day. In the sixteenth century, it embellished the formal portraiture of kings, nobles, and eminent men of the church. This time around, it serves to enhance the virile appeal of other kinds of mightily eye-catching men, all equally glitzy in their own fields: such crooners and thrusters as David Bowie, Michael Jackson, Alice Cooper, and various heavy-metal eardrum poppers; pint-size Malcolm McDowell, who acted through many shades of nasty in *A Clockwork Orange*; and, bringing up the rear, Darth Vader and the Storm Troopers in *Star Wars*. It seems that you just can't keep a good codpiece down.

It has strutted across the pages of comics written for juveniles of all ages. In an issue of *Doom Patrol* published in 1993, for example, a sad, lank-haired guy who just cannot seem to get his girl-squeeze finds himself miraculously transformed into Codpiece, a superhero whose

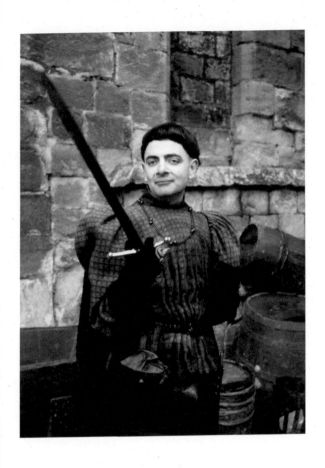

Rowan Atkinson as Prince Edmund, the Black Adder, in BBC's
The Black Adder, 1983

mightily erect, weaponized member shoots straight from the groin, breaks into a safe, and even emits ultrasound rays. And, perhaps most prominent of all, consider the wonderful Prince Edmund, the Black Adder (played by Rowan Atkinson in the British television series *The Black Adder*), who wears his cod-proud specimen long and black and savagely upcurling. As an aside to Lord Percy, just before the queen strolls by and takes a swipe at the thing, he says, "Let's go for the Black Russian! It always terrifies the clergy!" And he did go for the Black Russian, and what a mighty swaying dong it was! You can marvel at it on YouTube. The global fame of the Black Russian was so great that, in 2010, Cameo Auctioneers sold it for 850 pounds. *Eight hundred and fifty pounds* for a mere codpiece! The head spins like a top.

Oh, But Wait a Minute ... Do They Bite, Master?

What exactly is in this compound word, "codpiece"?

To get our etymological bearings, we need to consult the greatest dictionary of vulgar parlance ever compiled in the English language. Captain Francis Grose's *A Classical Dictionary of the Vulgar Tongue* was first published in London in 1785, and it has quite a lot to say about cods, codders, codgers, and codpieces, terms that are all, of course, part of the same family. "Cods" means scrotum, and it was also, as it happens, a nickname for a curate: "A rude fellow meeting a curate, mistook him for the rector; and accosted him with the vulgar appellation of Bol—ks the rector; No, Sir, answered he, only Cods the curate, at your service."[2] In Anglo-Saxon England, a small bag was also called a cod. By the eighteenth century, a cod came to be known, by extension, as a goodly sum of money. "Codders," a word much used in London, were folk employed by gardeners (usually Welsh women) to gather peas. "Codger" meant, then as now, an old fellow. Captain Grose defines the codpiece itself as "the fore flap of a man's breeches," and then immediately cites a snatch of humorous banter leveled at patient anglers by watermen: "Do they bite, master; where, in the codpiece or the collar?"

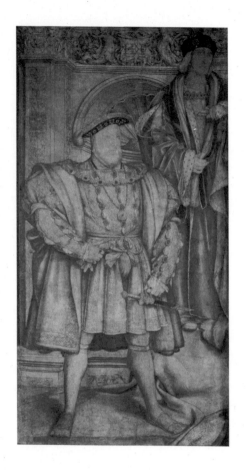

Hans Holbein the Younger, *King Henry VIII; King Henry VII*, c. 1536–1537. Ink and watercolor on paper, 101 ½ × 54 inches (257.8 × 137.2 cm). National Portrait Gallery, London

Tudor Henry Stands Proud

Our minds might well wish to encourage us to look else-where—to appreciate, for example, the symbolic signifi-cance of this august scene, in which the deceased Henry VII appears behind his son, raised higher and seeming to anoint him by his very presence. However, we sim-ply cannot stop ourselves from admiring the extraordi-nary, swell-headed codpiece that juts up and out like a ship's prow from between the stout, well-spread legs of Henry VIII.

The portrait was likely installed in Henry VIII's privy chamber of Whitehall Palace, which was tragically con-sumed by fire in 1698. The fire, paradoxical though this may sound, was a stroke of good fortune in one respect. Why? Because what we see here, the surviving prepara-tory study for the wall painting, perfectly focuses our attention on our principal object of interest: Henry's codpiece.

What remains of this study, housed at the National Portrait Gallery in London, is a mere fragmentary shadow of the painting that a select, privileged few would have seen in the privy chamber. It represents only the lefthand side of the wall painting, as we can see from a copy of the original by a painter called Remigius van Leemput. Its having been edited down in this way means that the cod-piece is center stage. Although it has to be said that the copy made more of the codpiece in another way: it stood out by being a slightly different color.

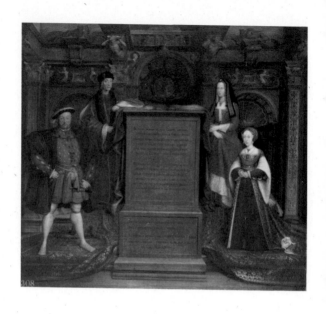

Remigius van Leemput (After Hans Holbein the Younger),
Henry VII, Elizabeth of York, Henry VIII and Jane Seymour, 1667.
Oil on canvas, 35 × 39 inches (88.9 × 99.2 cm). Royal Collection
Trust, Hampton Court Palace

In Holbein's drawing, Henry VIII stands unsmiling, chisel-bearded, like a bastion or a great, weathered oak. Solid, steady, sturdy, purposeful, he shows off his magnificent organ of generation in all its cloth-pampered semirotundity. It threatens to unfurl in front of our very eyes like a giant snail, or so we are led to fantasize. Here is the kingly codpiece writ large, making much of its prize. Close by, the king's determinedly closed fist sports a beringed finger. Everything conspires to show off his physical potency and massiveness. He fills the stage with a commanding presence. Has heaven ever before conjured so broad a pair of shoulders? Do you know of any other monarch who is as wide as he is long? He blocks our view. He consumes our very looking. He is an object to hang things from, a species of ornate scaffolding from which depend ribbons, cloaks, chains, a ceremonial sword, and more. His hat tilts like a wonky platter.

The codpiece itself emerges, rather coyly, from the pleated doublet, as if from between a pair of curtains drawn aside to show off a spectacle or, perhaps, an audaciously rascally trick. It both suggests and enhances the size and outthrustingness of the member itself. And above it all there hovers a pretty, nattily tied bow of yielding fabric, as if the king's genitals were a gift to the fortunate.

Henry VIII was around forty-six years old when Holbein made this work. He may even have impregnated his third wife during the period in which he posed for this portrait—Edward VI, his third legitimate child and

his successor, was born in 1537. There is not much to like about this brutal man's image and the swagger of his codpiece. It reminds us, perhaps, of the divorces and beheadings for which this monarch is so well known. It reminds us, too, of how he tried to make up for his dynastic shortevity by wowing the whole of Europe at every opportunity. He dressed up to the nines. No wonder that visitors to the palace remarked upon the fear-inducing wonder of the painting. "Anyone who sees it gets a fright; it seems as if it is alive," remarked one observer.[3] Others were said to feel "abashed" or "annihilated" in its presence. Could codpiece envy have played a part in any of this? The entire known world certainly seemed to pivot around Henry's choice of member enhancement.

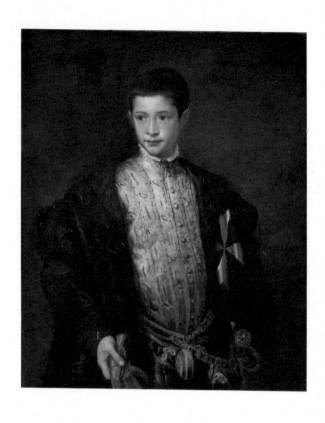

Titian, *Ranuccio Farnese*, 1541–1542. Oil on canvas, 35 ⅜ × 29 inches (89.7 × 73.6 cm). National Gallery of Art, Washington, DC. Samuel H. Kress Collection

A Puzzling Venetian Codpiece

To Titian, a mighty phallus was an object of wonder. Indeed, some of his portraits suggest as much. And yet in his works there is often more, or perhaps less, than meets the eye. We must hesitate before drawing over-hasty, sensationalizing conclusions about what happened behind closed doors in the sixteenth century.

Few painters equal Titian in his boasting of the manliness of men. But the manliness of a mere boy of twelve? Let us consider one of his great, codpiece-heavy portraits. Ranuccio Farnese was just twelve years old when Titian completed his painting of him in 1542. A son of one of Italy's wealthiest families, the boy was destined for a life in the church: he was already the prior of a religious foundation in Venice when he sat for Titian, and he soon became a cardinal, at the age of fifteen. His demeanor in this painting is, suitably, almost exaggeratedly modest, in fact quite touchingly, boyishly so. See how he looks askance. He has no particular desire to seize our attention or show off his boyish beauty. There is no braggadocio in this painting, no unusual degree of self-display (except, of course, for the wish on the part of the family to show off the costly fabrics they could so easily afford). There is no suggestion that the startling red codpiece—which looks to us as if it might be the repository of something coiled to strike—is there to show off the boy's virility, as a means of indicating that the Farnese line will continue. What is more, there is

nothing irreligious about making such a feature of the sweet promise of the phallus. Is Titian likely to have offended the family by doing something outrageously inappropriate? Not at all. He was canny, always.

And so we might say that this codpiece, for all its extraordinary prominence—look at the way it seems to drag the boy's clothes down, as if it were almost impossibly burdensome—is perhaps more to be regarded as a charming decorative feature than anything else. Furthermore, we must bear in mind that the work was painted by Titian as a presentation portrait for the boy's mother, which suggests that what appears memorably prominent to the eye of the beholder now may not have seemed so in northern Italy in the mid-sixteenth century. It was as normal to wear a codpiece of this kind as it is to wear, say, a padded bra in our own day. And yet, and yet, we still wonder about it, as our eye drifts with such ease in its direction, and whether this attraction is meant to happen, given that the codpiece is so central to the painting and so rampantly forward-facing, unlike, say, the boy's glance. Note how the parting of his ponderous black cloak seems to both emphasize and frame the codpiece, and how the loose-fitting, low-slung belt beckons our eyes down in its direction.

François Rabelais and the Swelling Greatness of Gargantua's Codpiece

The humor of the codpiece preoccupied François Rabelais, that sixteenth-century French literary genius of a renegade monk. How fortunate it is that his prime coincided with that of the codpiece itself! Had the codpiece not existed, history would surely have invented another gross object of allure in order to beguile and delight Rabelais and force-feed his appetite for bawdiness. The French word he frequently used in his wayward masterpiece *Gargantua and Pantagruel*, "*braguette*," makes us laugh to this day. Who has not, unself-consciously carrying a baguette beneath his arm in a Paris street, reflected upon the fact that only a single letter, *r* (which surely invites us to enter the outrageously scatological world of Rabelais), separates the sixteenth-century French word for codpiece from a mere baguette, that faux cod-phallus, crispy and hard on the surface yet so yielding at its center?

But what, exactly, did Rabelais himself make of the codpiece? It first turns up as an important feature in his preposterously long-winded, cod-academic description of the monstrous Gargantua's clothing:

> For his codpiece were used sixteen ells and a quarter of the same cloth, and it was fashioned on the top like unto a triumphant arch, most gallantly fastened with two enamelled clasps, in each of which was set a great emerald, as big as an orange; for, as says Orpheus,

lib. de lapidibus, and Plinius, *libro ultimo*, it hath an erective virtue and comfortative of the natural member. The exiture, outjecting or outstanding, of his codpiece was of the length of a yard, jagged and pinked, and withal bagging, and strutting out with the blue damask lining, after the manner of his breeches. But had you seen the fair embroidery of the small needlework purl, and the curiously interlaced knots, by the goldsmith's art set out and trimmed with rich diamonds, precious rubies, fine turquoises, costly emeralds, and Persian pearls, you would have compared it to a fair cornucopia, or horn of abundance, such as you see in antiques, or as Rhea gave to the two nymphs, Amalthea and Ida, the nurses of Jupiter.

And, like to that horn of abundance, it was still gallant, succulent, droppy, sappy, pithy, lively, always flourishing, always fructifying, full of juice, full of flower, full of fruit, and all manner of delight. I avow God, it would have done one good to have seen him, but I will tell you more of him in the book which I have made of the dignity of codpieces. One thing I will tell you, that as it was both long and large, so was it well furnished and victualled within, nothing like unto the hypocritical codpieces of some fond wooers and wench-courtiers, which are stuffed only with wind, to the great prejudice of the female sex.[4]

With Rabelais having pricked our appetites in this way, we cannot but ask ourselves, What actually became of

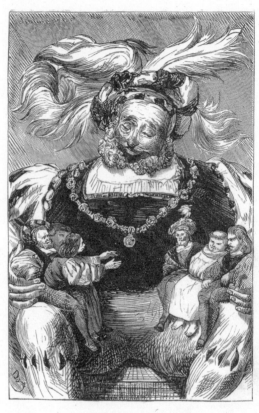

Panurge seeks the advice of Pantagruel and his friends as to whether he should marry.

Gustave Doré, Illustration from *The Works of Rabelais* (engraving), c. 1890 (first published 1854)

that further book, "on the dignity of codpieces," to which he so cod-teasingly alludes? It does not exist, try as one might to find it. Perhaps there is little to be said in support of the dignity of codpieces. Perhaps Rabelais is as much of a tease as the codpiece itself.

There is, however, a lot to be said about the fraudulence of the codpiece, how it seems to promise so much more than it delivers. The next Rabelaisian character to wield his own mighty cudgel in self-defense is Panurge, Pantagruel's long-suffering sidekick, who has much to say about codpieces in the third section of the book, which is named for him. For example, in a spirited debate with his opponent, Thaumaste, he shakes his *braguette* at him as if it were a weapon to be deployed in the conference chamber. Later, he removes his codpiece altogether, and in so doing admits to having not only deflated but emasculated himself, and he is mocked like a cuckold henceforth for lacking it. And so the removal of a codpiece is construed as a mark of the tail end of one's virility. It is time, O woe, to retire to a monastery. Panurge has solemnly, willfully, and self-sacrificingly divested himself of the principal item in the warrior's armor.

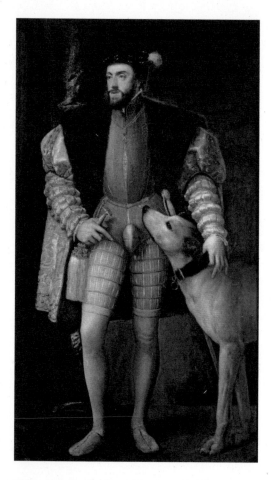

Titian, *Emperor Charles v with a Dog*, 1533. Oil on canvas, 76 ⅜ × 44 ⅜ inches (194 × 112.7 cm). Museo Nacional del Prado, Madrid

A Holy Roman Emperor's Codpiece in Heated Conversation with a Crotch-Curious Hound

This portrait, also by the ever ambitiously thrusty Titian, once belonged to a runt of a Stuart king of England called Charles I, who is always seen best when cranked up, his tiny legs flailing, on the back of a horse. Charles I, who suffered the misfortune of losing his head for having frittered away too much money (a great deal of it on important European art acquired from Italy) that rightly belonged to his enraged subjects, was five feet, three inches tall in his stocking feet and possessed the puniest pair of kingly thighs—and even punier legs.

The painting was presented to him by Philip IV of Spain, the great-grandson of Charles V himself. The sitter (or stander, rather), Charles V, was the Holy Roman emperor when Titian painted this portrait, and he is posed here in the company of a long-snouted dog with an evident fascination for the emperor's codpiece. You sense the dog's pleasure in taking in the king's sweet, circumambient aroma. Charles V was so delighted by Titian's work that he bestowed on him the title of Count Palatine, paid him five hundred ducats for his labors, and gave him a lucrative job as his official portrait painter.

Now, you may have noticed that the words "cod" and "dog" are near homophones—their sounds seem to rhyme, give or take one or two pesky consonants. They seem to snuggle up against each other, as if they were bedfellows. And there is something about the way

in which Titian has brought the dog's snout so sniffing-close to the emperor's firm, crisp, jaunty codpiece, about the nature of the dog's keen curiosity, that inclines us to puzzle over the snout of such a dog, and the codpiece itself, and all that it may or may not contain.

This is an exceedingly large dog—its raised muzzle is on the same level as the emperor's trim waist. The muzzle is long, fat, handsome, and confidently upthrusting. What does the emperor think of the fact that this dog's muzzle is so snappingly near to his genitals? He looks askance, into the middle distance. He barely seems to notice. In fact, he seems not to care one whit. Can it really be true, though, that a man of such eminence should not be aware that some huge, snap-happy dog is sniffing at his codpiece? Surely, his nonchalant mood of set-apartness cannot be an accident. It must be a pretense, because, as we are all well aware, portraits of this kind were carefully calculated exercises in diplomacy. Every skull, every tabletop globe, every beringed finger meant something. Every ferocious, level stare from the sitter told the viewer what he should think. In short, nothing was left to chance.

And so it is with this dog. This questing muzzle is, without a doubt, an allusion to the emperor's virility and the hidden eagerness of his member, its size and its perpetual, insatiable curiosity. The emperor's member is forever cocksure, on the prowl, on the sniff-about, on the hunt, like any keen hunting dog. Charles's forefinger is also pointing directly at his codpiece, although he pretends to be wholly unaware of that too.

The Sting of the Codpiece in William Shakespeare: A Morality Tail

The codpiece that will house
Before the head has any,
The head and he shall louse;
So beggars marry many.
—William Shakespeare, *King Lear* [5]

Stings in the tail about codpieces dip in and out of the plays of William Shakespeare, a playwright whose career roared to life toward the end of the sixteenth century, just as the codpiece was falling out of fashion. In Shakespeare's plays, the fool is often the wise man in disguise, the creature who reveals and tilts at man's folly. So it is all the more appropriate that he is often seen wearing something as flamboyantly anachronistic as a codpiece. In the second scene of the third act of *King Lear*, the fool sings lustily of the dubious good fortune of being inside a codpiece, so well padded and protected, and of how much more fortunate it would be to dwell there, in relative comfort, than suffer, like the poor of this world, the indignity of having nowhere to lay one's head in inclement weather. This is what the message seems to be when we first read these lines. But that's not all. The fool is, in fact, reminding us that if the urges of the flesh come to dominate a man's life, if the codpiece springs open like a jack-in-the-box at every swollen bosom or simpering look, he will end up no better than a beggar infected with

pubic lice. Altogether damning the codpiece as a nasty piece of work.

In *Measure for Measure*, Lucio, a coarse, brazen, scheming, uproarious fellow, defends a man for having played fast and loose with the mighty weapon concealed inside his codpiece. Is the use of this weapon sufficient cause to condemn a man to death? Of course not, argues Lucio: "Why, what a ruthless thing is this in him, for the rebellion of a codpiece to take away the life of a man!"[6]

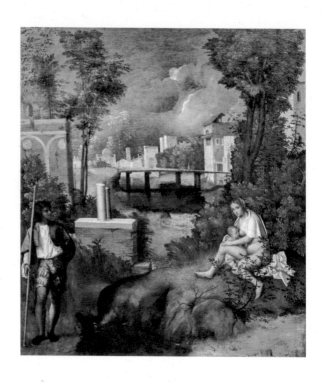

Giorgione, *The Tempest*, c. 1505. Oil on canvas, 32 ¼ × 28 ¾ inches (82 × 73 cm). Gallerie dell'Accademia di Venezia

A Storm Is Blowing Up in Giorgione's *The Tempest*

It would be difficult to find a painting that drips with quite as much honeyed sexual allure as Giorgione's *The Tempest*. And who in the world could possibly improve on the mysterious promise of its title? The very elements are about to rain down carnality. Our eyes shift from one side to the other, first taking in the coyness of the young man's elegantly embroidered codpiece, together with the length of his staff. The codpiece is partially disguised by a winningly attractive hillock of woven cloth, as if it were nothing but a bump causing the material to rise so enticingly. Then, having allowed our attention to flow across this deliciously fabricated Italian urban-cum-pastoral scene (Is this really Italy though?), with its receding villas, towers, dome, and low bridge overarching the river, we come at last to the naked woman on a grassy mound. She is glancing in our direction, as if we have just surprised her in the task of suckling this sweet babe. Who is this woman, and who is this expensively clothed admirer with a codpiece?

Critics have fumbled over explanations. She might be Venus, or she might be Eve. The setting could be Italy, perhaps the outskirts of Rome, or it could be Greece. And who is he, other than a beautiful, elegant, and prosperous young man who has happened along to admire her? His simple wooden staff gives him an air of rusticity, yet everything else about him—his clothes, his demeanor—gives the lie to that. There is just enough

delicious ambivalence about this dreamlike scene to indicate that anything is possible. The truth is that no one really knows what the painting portrays, and Giorgione himself certainly never told us. What no one can deny is the promise of coming sexual gratification that defines the painting's mood—from the strut of that pretty codpiece to the coy, and simultaneously not so coy, glance of the naked mother, seated on her swelling bank, her breast only just exposed and her legs sprawled invitingly wide. The handsome boy has stopped to look and smile and pose for her: see how he holds one hand behind his back and leans on his left leg, with his feet positioned just so, allowing time for his boyish good looks and his codpiece to be taken in. A tempest is brewing, almost irrespective of the threatening mood of the weather, but it is, in fact, this weather, this threateningly tempestuous weather—see the troubled sky!—that adds a mysterious tension to the whole. Where will they hurry off to if just moments from now it teems down? Is there space for three to bed down comfortably in that snatch of woodland?

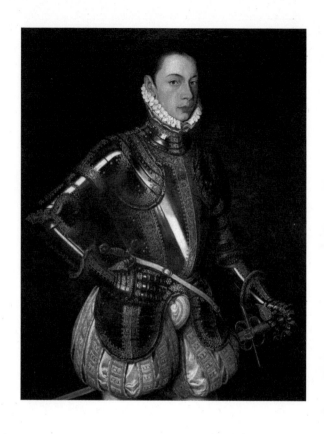

Alonso Sánchez Coello, *Portrait of Alessandro Farnese*, 16th century. Oil on canvas, 45 ¼ × 37 inches (115 × 94 cm). National Gallery, Palazzo della Pilotta, Parma

A Boy Soldier, with His Other Weapon

Half armor adds a certain teasing element to the depiction of the codpiece in this sixteenth-century portrait of Alessandro Farnese. The armor is both charmingly, almost finically, decorative and war-beckoning. The codpiece, on the other hand, is soft and round, mimicking the puffing out of his breeches, which sag from his elegant pinched-in waist like two gently slumping puddings. There are, then, two parts to him, both quite distinct. There is the warrior, and the lover, the creator of future generations of warlike young men such as himself. The codpiece is a reminder (and a guarantee of sorts) that this unbendingly stern young man is here both to fight and defend and to procreate. Shown at the tender age of fourteen—observe how thin his arm is!—Farnese was already a member of the Spanish army, as indicated by the crimson piping along his costume. His right hand, somewhat clawlike in appearance inside its gauntlet, rests with casualness, if not nonchalance, on his hip. His breastplate and right arm gleam fiercely. His face could scarcely be more impassive; he is a young man on maneuvers. But he is also much more than that: He fights. He protects. He impregnates.

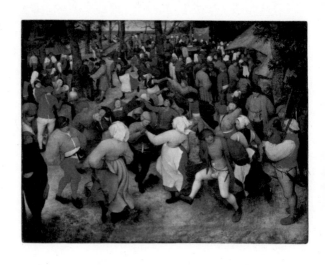

Pieter Bruegel the Elder, *The Wedding Dance*, 1566. Oil on wood panel, 47 × 62 inches (119.4 × 157.5 cm). Detroit Institute of Arts. City of Detroit Purchase

Several of the codpiece paintings we have examined can be characterized by a certain, rather surprising restraint—perhaps we could even call it pretense or dissimulation. The wearers, for the most part, are men, or boys, of wealth and great social standing: kings, emperors, aristocrats, exalted persons destined for positions of high influence in the church or army. Although they flaunt their codpieces, they do so subtly, almost pretending that the codpiece merely happens to be there. If the eye-boggling presence of the codpiece happens to prove that they are enormously virile—and that is what the codpiece suggests—well, so be it.

The uninhibited, all-doors-flung-wide-open world of Pieter Bruegel the Elder is quite different. We are far away from court or a privy chamber in this scene of a common wedding celebration, set somewhere in the Netherlandish countryside. Furious dancing is going on, to the accompaniment of the screech and skirl of pipes: see the piper in the foreground of the painting, at bottom right. He is the master of ceremonies, without a doubt. His rasping tunes encourage the peasants' drunken, lubricious weaving in and out. He brandishes the largest codpiece of them all, though not the most colorful one, which is, of course, the red one, flourished by the man in the left foreground. Red for the devil's influence, no doubt, and perhaps for the flames of the unassuageable roarings and rampings up of sexual

passion. All is riot here, near chaos, in fact—rude tumblings about, raucous whoopings and shoutings. We can almost hear the crowded, unmanageable din of it all, the wildness, the buffoonery. So little is left to the imagination of us snoopers at this gluttonous feast of rough sorts, drinkers, and colorful layabouts, to whom sexual display comes as second nature.

The three magnificent codpieces at the bottom of the painting, shown fully in profile so that we can scrutinize them in all their eager, shapely, passionate-to-be-of-service-madam, gigantic upthrustingness, form a colorful trilogy. These are no-holds-barred codpieces. And who among this crowd in excess of one hundred partygoers is sober enough to care anyway? They are codpieces, and wearers of codpieces, thoroughly unashamed of themselves. In fact, they are exulting in the sheer beastliness of men. See how the man in white breeches flings his legs wide apart so that our eyes can lap at what is on offer!

Research has shown that Netherlandish religious and civil authorities did not take kindly to Bruegel's vivid presentations of codpieces and general debauchery. After all, those lowlanders were stern Protestants. Some regarded the codpiece as an offense to the eye, and others as even a brazen attack on public morals.[7]

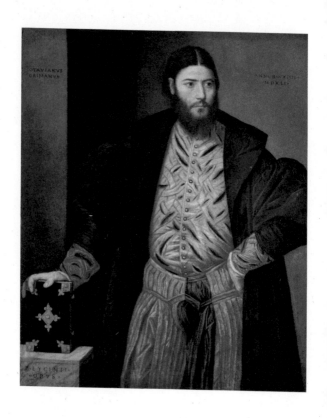

Bernardino Licinio, *Ottaviano Grimani*, 1541. Oil on canvas,
45 ⅜ × 37 ¾ inches (115.2 × 96 cm). Kunsthistorisches Museum,
Vienna

Perhaps surprisingly, the codpiece seemed to stroll along hand in hand relatively easily with Catholicism in the sixteenth century. There was no expression of general outrage from the purple cardinals, no powerful stench of immorality detected by the morality police. During a period when, thanks to the capricious dictates of ever changing European fashion, so much about the male person had become puffed up, extended, broadened, lengthened, the codpiece seemed to fit in quite well, contributing to a fabricated, fictionalized version of the male body. What is more, according to the caustic words of the playwright Thomas Dekker, writing in *Seven Deadly Sinnes of London*, the fashionable Englishman seemed to be a strange construction altogether, with parts assembled from here, there, and everywhere. His suit "is like a traitors body that hath been hanged, drawn, and quartered, and is set up in several places; his codpiece is in Denmark, the collar of his doublet and the belly in France.... Poland gives him boots: the block for his head alters faster than the feltmaker can fit him, and thereupon we are called in scorn 'blockheads.'"[8]

This racy portrait of Ottaviano Grimani, the twenty-four-year-old procurator of Saint Mark's Basilica in Venice, was painted by Bernardino Licinio in 1541. Grimani was second only to the doge, and his job was to look after the fabric of the great basilica. It was a religious appointment, then. Does this bearded young blade have a pious

air about him? He is wearing a red leather suit, with fur on the inside, distinguished by vertical slashes, a style imported from Switzerland. Its very raciness might suggest a degree of impiety. Note the two-tone codpiece. Luther and Calvin thundered against the immorality of this kind of display of public indecency.

Codpiece of King Henry VIII, 1540. Royal Armouries,
White Tower, London

Shooting from the Groin:
The Mighty Codpiece Goes into Battle

Armored codpieces would have been a familiar sight on the battlefield. As with all other fashionable codpieces of the moment, these metal iterations were exaggerated in size and pugnacious in attitude. In fact, they were an integral part of the mood of aggression and indomitability that armor expressed.

The codpiece often stands apart from the rest of the armor's articulated parts, as if it were a ferocious weapon ranking alongside swords, halberds, crossbows, and much else. It does not blend in with a fabric nor partly disappear within its folds. It pushes forth, up and out, with an almighty aplomb and an uncommon degree of arrogance. It says, Here I am, all fertility blazing. This weapon, quite as tough and swinging as a broadsword, seems to strike on behalf of the royal lineage it serves and represents, reminding the onlooker that it is steely in its resolve to go on, furiously procreating. No other codpiece is its equal. Henry VIII's magnificent specimen shown here (yes, again), together with the rest of his suit of armor, is on display in the Tower of London.

Codpiece as Joker: Some Wise Words from
the Great Essayist Michel de Montaigne and the
Great Satirist Samuel Butler

The codpiece, as so outrageously flaunted in the portraiture of the Renaissance, and decorated with bows, tassels, and other kinds of nonsense, suggests that well-born men strutted about with permanent erections. Priapism had evidently reached epidemic proportions. In spite of this, surprisingly little was written about the eruption of cod-phalluses when they were at the height of fashion, because almost everything else about the stylish male looked equally ridiculous and overblown: Why single out the codpiece for particular attention? However, a few openly recognized the funny side of it all the same. The French essayist Michel de Montaigne, for example, called the codpiece a "laughter-moving, and maids looke-drawing peece."[9] And even after the codpiece shrunk to a miserable pizzle of its former self, other items of male dress continued the self-preening nonsense. The padding, the slashing, the puffing out, the embroidering, and the bejeweling went on and on. Here is what the English satirist Samuel Butler wrote about the typical "huffing courtier" in 1667:

> He flutters up and down like a Butterfly in a Garden; and while he is pruning of his Peruque takes Occasion to contemplate his Legs, and the Symmetry of his Britches. He is part of the Furniture of the Rooms,

and serves for a walking Picture, a moving Piece of Arras. His business is only to be seen, and he performs it with admirable Industry, placing himself always in the best Light.... His Taylor is his Creator, and makes him of nothing.[10]

Although fashions may have changed almost a century later, little had changed about male vanity.

Poor, Disadvantaged, Codpiece-Lacking Man!

Even Philip Stubbs, a Puritan who foamed at the mouth in his *Anatomie of Abuses* (1583) over the outlandishly immoral excesses of fashion, barely wrote a word about the codpiece. In fact, it was not until more than half a century after it had disappeared as a fine and upstanding embellishment to men's clothing that it at last got its due in the English language, and even then it was in a rather roundabout way, and with no thanks to a mere Englishman at all.

In 1653 a Scottish knight with time on his hands called Sir Thomas Urquhart published the first two parts of his translation of *Gargantua and Pantagruel*, that great book of nonstop bawdry by Rabelais. The book is at pains to explain how man is at such a disadvantage when compared with the rest of nature. Only man, argues our monk, in a chapter titled "Why the Codpiece Is Held to Be the Chief Piece of Armour Amongst Warriors," lacks the kind of protection that a codpiece provides to all other things in nature:

> Behold how nature ... hath most curiously armed and fenced their buds, sprouts, shoots, and seeds ... by strengthening, covering, guarding, and fortifying them with an admirable industry, with husks, cases, scarfs and swads, hulls, cods, stones, films, cartels, shells, ears, rinds, barks, skins, ridges, and prickles, which serve them instead of strong, fair, and natural

codpieces. As is manifestly apparent in pease, beans, fasels, pomegranates, peaches, cottons, gourds, pumpions, melons, corn, lemons, almonds, walnuts, filberts, and chestnuts.[11]

Nature gave no such protection to man, creating him "naked, tender, and frail, without either offensive or defensive arms."[12] No wonder Yoland, the wife of Lord Humphrey de Merville, seeing her lord going off to war on his horse, with his staff of love and packet of marriage wholly unprotected, laments as follows in the third book of the Shitbrana of Paltry Wenches:

When Yoland saw her spouse equipp'd for fight,
And, save the codpiece, all in armour dight,
My dear, she cried, why, pray, of all the rest
Is that exposed, you know I love the best?
Was she to blame for an ill-managed fear,—
Or rather pious, conscionable care?
Wise lady, she! In hurlyburly fight,
Can any tell where random blows may light?[13]

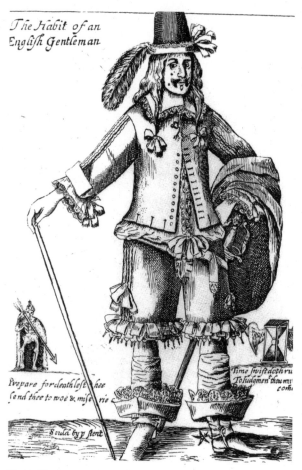

The Habit of an English Gentleman, c. 1645. Engraving, 6 ⅝ × 10 inches (16.6 × 25.3 cm)

Oh, to Be an Englishman in the 1640s!

In the 1640s a satirical engraving titled *The Habit of an English Gentleman* freely mocked the top-heavy sartorial idiosyncrasies of the fashionable Englishman. And here, we see him in all his ridiculousness, pomp and feathery outpouring, barely able to walk for all the au courant clutter designed to show him off at his best—or worst. His long hair droops and drizzles like a wet spaniel's. He is a one-man study in the art of beribboning. And, ah yes, even the codpiece, like everything else about him, gets its descriptive due. The helpful text informs us, should we have failed to notice from the picture, that he sports a "long wasted doublet unbuttoned halfway . . . his sleeves unbuttoned . . . his breeches unhooked ready to drop off, his shirt hanging out, his codpiece open tied at the top with a great bunch of riband." The artfully casual look, then.

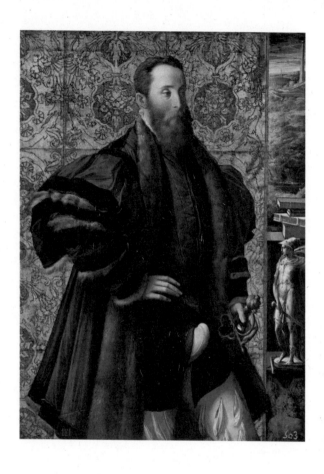

Parmigianino (Girolamo Francesco Maria Mazzola), *Pietro Maria Rossi, Count of San Secondo*, 1535–1538. Oil on panel, 52 ⅜ × 38 ½ inches (133 × 98 cm). Museo Nacional del Prado, Madrid

Pietro Maria Rossi, Count of San Secondo, and the Martial Lunge of the Codpiece

Pietro Maria Rossi was a wealthy aristocrat of some note, both a feudal lord and a Renaissance prince in the pay of the Holy Roman emperor Charles v, and he looks every inch of it, from top to toe. Few codpieces possess as much coolly ruthless martial swagger as this one. This codpiece does not announce itself shyly. Quite the opposite, in fact. It does not try to dissimulate in any way, or disguise itself beneath the colorful patterning of fabric, as if it were an unexpected bump in the wallpaper. Its shape seems to do no more nor less than replicate, quite baldly, quite unashamedly, the shape of the very penis it pretends to sheath and hold rampantly eager, as if to say, Here is the graspable truth of it! And what a corker of a gear stick it is. In short, it resembles a gun in a holster. One of Dali's bendy guns, perhaps. What is more, its close proximity to the count's sheathed sword—see how his rather small hand clutches its hilt, which mimics the direction of the codpiece—scarcely needs to remind us that this is a war not only between the Holy Roman emperor and his many enemies but also between men, and that few are likely to be the count's match in either department.

Everything comes together in this display of overweening masculine confidence. It is all so costly, so luxurious—and it is a luxuriousness sanctified, if not blessed, by antiquity: see the sculpture of the naked

swordsman at right. Who does this statue represent: Mars, Minerva, Perseus? Or a dreamy mingling of all three? He is wearing the Corinthian helmet of Pallas Athene, which is very useful in difficult situations because it makes its wearer invisible. As with the count and his codpiece, the youthful figure seems to announce both martial vigor and sexual allure. Note the transparent clothing and the proximity of the barely disguised penis to the sword, which the figure is in the process of unsheathing. Meanwhile, the count himself, in his magnificent fur wrap, set against a wall of expensive gold brocade, could scarcely look more aloof from all worldly matters. He stands a short distance away from a parapet, which proves, at a stroke, the wealth at his command. There is an impressive stack of books, too, as if to demonstrate that his unparalleled gifts to the world are threefold: swordsman, lover, and man of letters. But most of all, there is this showy codpiece, which seems to confirm that the count's ancestral line will long continue, and woe betide you should you happen to disagree.

No one disagreed. He had nine children by Camilla Gonzaga before he died at the tender age of forty-three.

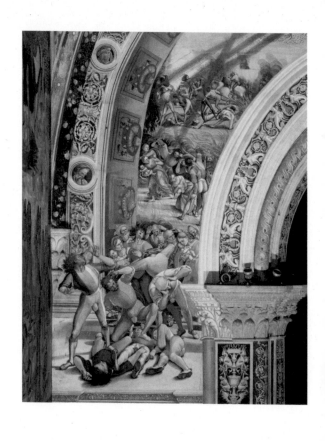

Luca Signorelli, *The End of the World* (detail), 1500–1503. Fresco.
San Brizio Chapel, Orvieto Cathedral

Luca Signorelli's Sacred Rough-and-Tumble

Is the codpiece less about sexual allure than martial vigor? Must the mightiest sword of all always be part and parcel of the man himself? Here we have an untidy troupe of writhing, gesticulating soldiers, rudely joshing on an interior archway of yet another sacred space: the cathedral of Orvieto in central Italy. This is a mere detail from a dramatic cycle of outrageously revealing frescoes depicting the Last Judgment, painted between 1500 and 1503 by Luca Signorelli. Seldom has so much nudity been on display in a cathedral.

This moment in the larger scene is outlandishly balletic, and it offers an unparalleled opportunity for the codpiece to strut the catwalk. These elegantly clothed young fighters are the male models of their day: admire the broadness of their shoulders and their muscular calves, swelling chests, magnificent buttocks, and excitingly unruly hair. What a game of rough-and-tumble this is, with one man's hand thrust against another's codpiece, and another man's face tilting up directly into the codpiece of his kneeling companion. Seldom has a cluster of codpieces been defined so openly, within a scene of such boisterousness, and with such a show of manly pride, one worthy of Bruegel himself. They look like overripe fruit hanging from the bough of the groin, poised and displayed for quick picking.

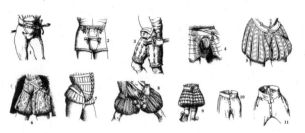

1. Ajoutée au haut-de-chausse (XVᵉ siècle). — 2. Liée par cordons (XVIᵉ siècle). — 3. Diverse (XVIᵉ siècle). — 4. Rigide d'armure (XVIᵉ siècle). — 5. Rajoutée à la trousse (1585). — 6. Philippe II (1572). — 7. Dissimulée (1580). — 8. Allemande à bouppettes. — 9. Fermée par cordons (1635). — 10. A boutons visibles (1640). — 11. De culotte (XVIIᵉ siècle).

BRAIES — 1. Rattachées au brayer. — 2. Brain d'ouvrier (XIIIᵉ siècle). — 3. Braie courte. 4. XIIᵉ siècle. — 5. XVᵉ siècle.

de *braies*. Ces sortes de caleçons ou pantalons roulés à la ceinture avec le *braiel*, descendaient jusqu'à la cheville. Plus tard, les Grecs et les Romains les adoptent. Au Moyen Age, hommes et femmes portaient des braies. Des boucles ou attaches permettaient de retrousser les braies sur les hanches. Les anciens manuscrits en fournissent maints exemples. Lorsqu'on porta des chausses indépendantes l'une de l'autre, se rattachant sur les hanches à la ceinture, les braies furent une sorte de caleçon de bain très court, vêtant le bassin, par-dessus lequel la chemise pendait devant et derrière. C'est de ces longues braies, conservées par les marins, que dérivèrent les *grègues* et les *chausses à la marinière*, ancêtres de nos *caleçons* et *pantalons*. (Voir ces mots.)

BRAIEL ou BRAYER (s. m.). Le *braiel* ou *brayer* était une ceinture qui retenait les braies. Dès le XVIᵉ siècle, on nomma aussi *braiel* une ceinture orthopédique destinée à maintenir les hernies.

BRANC (s. m.). Sorte de blouse ou sarrau au XVᵉ siècle.
Comme arme, il est difficile de préciser si

ce terme, employé surtout en poésie, signifie épée ou lame.

BRANCADE (s. f.). Chaîne de forçat.
BRANCHE (s. f.). Voir Erès.
BRANDEBOURG (s. m.). Le *brandebourg* était

Brandebourgs.
1. Boutons à queue (1637). — 2. Heiduque hongrois (1660).

44

What a Swell-Headed Boaster Is the Codpiece!

The codpiece is all about boastfulness and braggado-cio, sad men pretending to be more than they could ever hope to be. Its very name in different romance languages makes this abundantly clear: *bragueta* in Spanish, *braga* in Italian, and *braguette*, of course, in French. Don't these words seem eager to sound out their meaning? They rattle against the teeth and explode violently out of the mouth.

In 1511 a noble lord of London called Sir Thomas Knyvett played the part of Vaillant Desyr in that year's Westminster Pageant, a parade in honor of the lord mayor that proceeded through the thronged streets of London. He wore a codpiece that went by the name of Desyr.[14] How the very word breathes out its meaning!

One of the finest pictorial presentations of different kinds of codpieces from the fourteenth to the sixteenth century—from the simple triangular pouch to a German specimen with giant bell-like testicular knots—is found in Maurice Leloir's *Dictionnaire du costume*. These eleven representations are a visual feast of defiant, strutting, lunging, open-legged posturing. The book was published in 1940, at which doleful hour France was suffering occupation by Nazi Germany. Would symbols of past virility offer future hope and encourage spasmodic bouts of warlike behavior among the Maquis in the south?

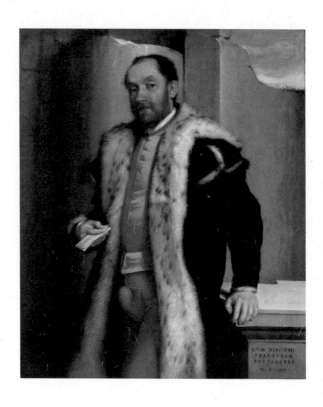

Giovanni Battista Moroni, *Portrait of Antonio Navagero*, 1565.
Oil on canvas, 45 ½ × 35 ½ inches (115 × 90 cm). Pinacoteca di
Brera, Milan

Antonio Navagero, Half Sensible, Half Priapically Mad as a Hatter

Most of the great codpiece paintings of the sixteenth century are portraits of relatively young men of promise and esteem, not scheming, audacious, or self-deluded oldsters for whom the presence of a large codpiece, ramped up at front-middle, might look a little, well, out of place. You could say this is an older man's wishfulness, boastfulness, fancifulness, pretense exaggerated to a ridiculous degree. Here we have such a portrait, and it seems to be all of a piece, with the sole exception of the codpiece itself. Navagero was the podesta, or chief magistrate, of Bergamo, in northern Italy, and almost everything about his depiction here speaks of serious-mindedness. The letter he holds indicates to the viewer that he is in this world to do grave business. The heavy luxuriousness of his clothes adds weight to his eminence. His hand rests on a surface that rather cunningly resembles a gray stone pediment from antiquity.

The portrait is a celebration of his official appointment—see his position inscribed in the lower right in Latin, the diplomatic language of Europe until well into the eighteenth century. He is burdened with the cares of age and civic responsibility: his hair is receding, and his brow is furrowed. He could be any diplomat, any bishop, any successful politician, were it not for this, well, almost clownishly extravagant, curliewurly, whooping-it-up red codpiece, which turns him into the

very devil of heavy-breathing carnality, a shrieking object of desire forever on the lookout. This level of ostentation for such a grave older man is almost side-splittingly bizarre. How could a man choose to make himself look so ridiculous? Can men be self-deluded to quite this degree? Oh yes. But it is worth noting that the artist and sitter are in collusion here. Those who scrutinized this painting would have admired the sheer extravagance of the codpiece and understood its significance in highlighting Navagero's continuing potency.

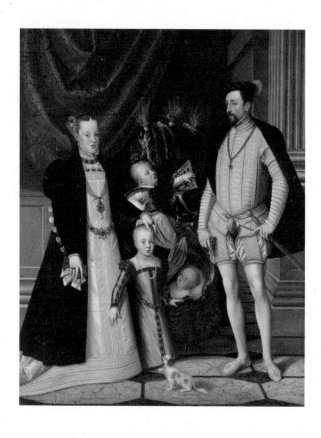

Attributed to Giuseppe Arcimboldo, *Maximilian II (1527–1576) and his wife Maria of Spain (1528–1603) and his children Anna (1549–1580), Rudolf (1552–1612) and Ernst (1553–1595)*, c. 1563. Oil on canvas, 94 ½ × 74 inches (240 × 188 cm). Kunsthistorisches Museum, Vienna

Codpieces in the Family Way

This mild-mannered and relatively conventional group portrait of a fine and upstanding sixteenth-century Catholic family shows us Maximilian II, soon to be appointed Holy Roman emperor, together with his wife, Maria of Spain (the daughter of Charles V), and their three children. It has been attributed to a man called Giuseppe Arcimboldo, who is renowned for his fantastical portraits of human heads constructed from fruits, vegetables, and plants. How great a distance is there between a swelling gourd or a curvy cucumber and a codpiece such as Maximilian's?

In this portrait, the entire family appears to be paying discreet homage to the magnificence of this man's codpiece. It is almost as if each child is patiently standing in line to pay tribute to that which brought him or her into being (while unfairly ignoring Maria, an important member of the childbearing union). (The babe in the wickerwork cradle is a mite too young to care from whence he came, and so he is not even looking in the right direction.) The codpiece itself emerges from the darkness between the fine crumpled silk of Maximilian's doublet. A belt with a gold buckle sets it off. It shoots up curvaceously, like a rearing horse. Maximilian himself looks as otherworldly as any saint, accepting the homage that is due to his codpiece, and is not in the least surprised. The scene has just a touch of an air of the sacred about it, despite the fact that no

religious symbols are present. Perhaps the owner of a great codpiece such as this may have plans to add yet more to the fruits of his labor; after all, Maria is scarcely of child-bearing age. And this is exactly what happened. They notched up a grand total of sixteen children in twenty-eight years.

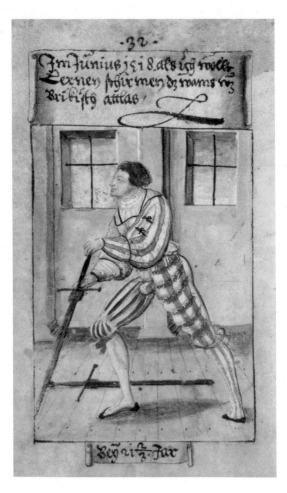

Matthäus Schwarz, Illustration from *Klaidungsbüchlein*, 1518

One of the earliest books of fashion—or little "book of clothes," as it was described by its author—was created by Matthäus Schwarz, an accountant from Augsburg, Germany, during the first half of the sixteenth century. It is, somewhat, a version of an illuminated manuscript, with a series of plates commissioned from competent local artists, whose works possess much naive charm, all painted in tempera on parchment. The images show off Schwarz and his son as prosperous men going about their daily lives, pursuing the fashionable activities of the privileged, in what would have been fashionable contemporary clothing. The caption to this painting simply describes Schwarz lunging forward, his hand, on the pommel of his sword, waiting to be pressed into use. The script says it all, baldly and briefly: "In June, 1518, when I wanted to learn fencing. The doublet was silk satin from Bruges." And beneath is a factual detail about the pupil: "around 21 years old."

What gets no mention in that text is the codpiece, which serves as a kind of round-ended protective box for the lunging and parrying fencer, useful but not too ostentatious from the point of view of fashion; his legs get much more attention. We see the tidily serviceable box of tricks very clearly as he scissors his legs. It puts us in mind of the proliferation of codpieces that, under slightly different names, have been widely used by sportsmen and dancers ever since.

The strange literary afterlife of the codpiece continued well into the seventeenth century and beyond. The term took on a wider, looser meaning, sometimes standing in for what we might now call the crotch or fly of a pair of trousers. Long after the word "codpiece" had stopped being of use to describe our particular object of fascination, it came to sum up the frenzied buzz of the entire region, you might say. It seems "codpiece" has been altogether too memorable for the imagination to let it go. Everyone still laughs at that rude word, don't they?

When, in 1737, a gentleman called Henry Purefoy described to his tailor how he wanted that useful slash in the front of his breeches to look, he advised that they were not to have a "flap at the codpiece but only buttons and buttonholes."[15] At other times, the word seemed to mean little more than sexual arousal, as in the case of the Frenchman who arrived in London "hot in the codpiece," the remedy for which was locating a desire for "a Cooler." Another swaggering airhead, in a play by Thomas Nashe, bragged of having a codpiece "as big as a *Bolognian* sawcedge."[16]

And then there was the case against coffee. Who ever would have guessed it, but in 1674, a satire of the fashion for coffeehouses warned that coffee could cause impotence. A great petition was launched against "the excessive use of that drying, enfeebling liquor." The "continual sipping of this pittiful drink" had a most unfortunate

consequence. It tied up "the *Codpice point*" and rendered those that use it as "*Lean* as Famine.... They come from it with nothing *moist* but their snotty Noses, nothing *stiffe* but their Joints, nothing *standing* but their Ears."[17] This is an area around which there has been little serious research to this day.

And then there was the case of the battle between references to male and female genitalia that, in one account, turned into a bone of contention between the busk and the codpiece. "Busk," do I hear you ask? It's the stay, often made of bone, that stiffened a woman's corset, running down from between the breasts to a point just shy of the pelvis—or, as the writer Randle Holme delicately expressed it in the seventeenth century, "it reacheth to the Honor."[18] Busks, like codpieces, were often held in place by ribbons. So what happens when you put a busk next to a codpiece in a text? You begin to talk dirty, as in this fictional snatch of verbal sparring between some ladies and gentlemen, written in 1685:

> A Lady was commanded to put her busk in a Gentlemans codpiss. Another Lady was commanded to pull it out, which occasioned some sport, for she laying hold upon something else, after two or three pulls gave over, excusing her disobedience, by pretending that the busk was tackt to the Gentlemans belly.[19]

This was written about one hundred years after the last real codpiece had swung itself off the public stage in a

fit of vainglorious pique. Despite the fact that the cod-piece was no longer a fashionable male accoutrement by the time this was written, references to everything that it represented were still very much understood and in play verbally.

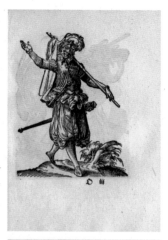

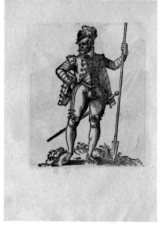

Jost Amman, Illustrations from *Kunstbüchlin* (woodcuts), 1578/1599

Up? Down? Coiled? Snoozing?:
A Daily Dilemma of Codpiece Attitudinizing

In which direction is the codpiece to point? Is it to be curled up to strike like a rampant snake, coiled in dangerously deceptive ever-readiness, or merely stuffed or bundled into a tidy, defensive, boxlike shape so that we fantasists have simply no idea which direction it, having sniffed the randy, spiced, and perfumed air, purposes to move next? Was it to come at us face-forward, side-on, or straight-up-and-then-in, like a climbing rocket? Which approach might appeal most to the slavering onlooker? All these possibilities were dandled and dallied during those raunchy decades of the sixteenth century, the codpiece's most sanctified historical moment.

Here are a couple of codpieces on the stride illustrated in Jost Amman's *Kunstbüchlin* of 1578, a book of woodcuts showing fashionable styles of dress. In the top illustration, the codpiece, all prinked and fussed over with fabric, looks like the smooth, firm, nutty heart of a flowering vegetable, some florid version of a large, unruly, tough-leaved cabbage perhaps. It looks not so much minatory as prettily, pleasingly gift-wrapped. The codpiece on the second figure is, oh my goodness, a real belter of a thing, at least the equal in potency and panache of that deadly pointed spear, and, meanly coiled as it is between those plumping thighs, not even *pretending* to be at rest.

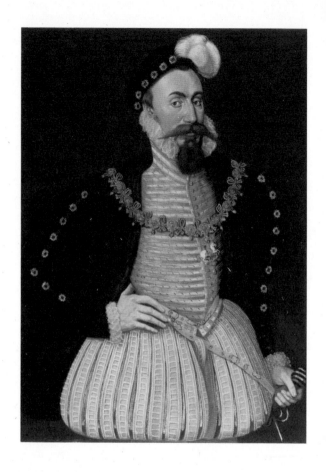

Unknown English workshop, *Robert Dudley, First Earl of Leicester*,
c. 1575. Oil on panel, 38 × 27 inches (96.5 × 68.6 cm). National
Portrait Gallery, London

Deflating the Male: The Sad Decline of the Codpiece

What surprises, and perhaps even disappoints, about this otherwise over-the-top, self-preening portrait of an English aristocrat called the Earl of Leicester, painted around 1575? Just look at the length of that mustachio, the cut of that beard, the winning angle of the hat, those ruffs about wrist and neck, the oh-so-self-consciously and lightly posed hand on hip, and the swell of that ballooning trunk hose! But the codpiece, which had shrunk to near invisibility by this point in the reign of Elizabeth I, is nearly missing! Don't let that long and wandering belt saw away at this poor aristo's withering manhood! The codpiece registers barely a squeak of a peek. What happened to all that cocky bravado of yesteryear? The codpiece has retreated into hibernation.

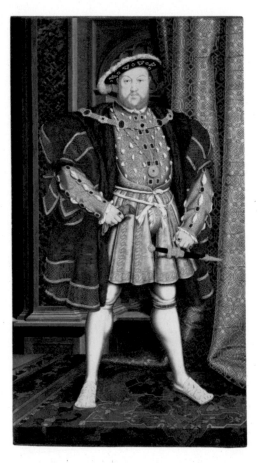

Hans Holbein the Younger, *Henry VIII*, 1537. Oil on panel,
94 × 53 inches (239 × 134.5 cm). Walker Art Gallery, Liverpool.
National Museums Liverpool

Tudor Henry's Final Plea from the Tomb: For God's and Olde England's Sake, Bring Back the Codpiece

We began our spasmodic survey of the fantastical, make-believe world of grossly inflated codpieces with Tudor Henry, and so it is only fitting to end with him. We were reminded of his enduring newsworthiness as wife-head-lopper and fantasy-phallic stage-strutter in a recent article on *Huffpost*. Written from the grave by the king himself on September 1, 2016, the article is a plea for the return of the codpiece and for men to be encouraged, yet again, to publicize their richest endowments as widely and loudly and vividly as possible.[20]

It is wholly unfair, the king argues, that women should be given every opportunity to show off the inflated promise of their upper halves, while men whimper in shady corners, the best of them concealed behind flat-fronted trousers. And yet the king himself, for all his endeavors to show off the airy promise of the magnificence of his manhood in public, failed in the end to provide a male heir who would himself sustain the dynasty. He had a son, Edward VI, who was crowned at the age of nine. Unfortunately, the poor boy died of a suppurating tumor of the lungs six years later, at the age of fifteen. After that, Henry's daughters took it in hand to rule over the realm, first Bloody Mary and then Elizabeth, who, much to the disappointment and frustration of the ghost of her father, had so little interest in phallic fun (real or pretend) that she was celebrated later in her life for

her virginity. After the death of Elizabeth, and the final snuffing out of the Tudor line, a mere Scotsman by the name of James I took charge. And with the return of the draughty kilt, alas, the private joys of manhood threatened to freeze over yet again, across the entire realm of mirthless Britannia.

Notes

The epigraph is from a conversation between the author and the artist, December 8, 2018.

1 Thomas Lodge, "Wit's Miserie," in *The Complete Works of Thomas Lodge*, p. 33.
2 Francis Grose, *A Classical Dictionary of the Vulgar Tongue*, p. 92.
3 Thomas Betteridge and Suzannah Lipscomb, ed., *Henry VIII and the Court*, p. 53.
4 François Rabelais, *Gargantua and Pantagruel*, book 1, chapter 8, pp. 31–32.
5 William Shakespeare, *King Lear*, 3:2:105–108.
6 William Shakespeare, *Measure for Measure*, 3:2:27–34.
7 *Bruegel: The Hand of the Master*, p. 262.
8 As quoted in Herbert Norris, *Tudor Costume and Fashion*, p. 556.
9 Michel de Montaigne, *Essayes of Montaigne*, p. 254.
10 *The Genuine Remains in Verse and Prose of Mr. Samuel Butler*, pp. 80–81.
11 François Rabelais, *Gargantua and Pantagruel*, book 3, chapter 8, p. 319.
12 Rabelais, *Gargantua and Pantagruel*, p. 321.
13 Ibid.
14 *The Great Tournament Roll of Westminster*, p. 56.
15 *The Purefoy Letters, 1735–1753*, p. 301.
16 Thomas Nashe, *Have with You to Saffron-Waldon*, R2r.
17 *The Women's Petition Against Coffee*. On the petition specifically, see Markman Ellis, *The Coffee House*, pp. 136–138.
18 Randle Holme, *The Academy of Armory*, book 3, chapter 3, p. 94.
19 Edward Phillips, *The Mysteries of Love & Eloquence*, pp. 14–15.
20 Anonymous, "Stop the Oppression."

Bibliography

Anonymous, "Stop the Oppression: It's Time to Bring Back the Codpiece." *Huffpost* online community forum, September 1, 2016 (updated September 8, 2016).

Betteridge, Thomas, and Suzannah Lipscomb, ed., *Henry VIII and the Court: Art, Politics, and Performance*. London: Routledge, 2016.

Bowman, Karen. *Corsets & Codpieces: A Social History of Outrageous Fashion*. Barnsley: Pen & Sword Social, 2015.

Bruegel: The Hand of the Master. Exhibition catalogue. Vienna: Kunst Historisches Museum Wien, 2018.

Cunnington, C. Willett, and Phillis Cunnington. *Handbook of English Costume in the Sixteenth Century*. London: Faber and Faber, 1954.

Ellis, Markman. *The Coffee House: A Cultural History*. London: Weidenfeld & Nicolson, 2004.

The Genuine Remains in Verse and Prose of Mr. Samuel Butler. Volume II. With notes by Robert Thyer. London, 1759.

The Great Tournament Roll of Westminster: A Collotype Reproduction of the Manuscripts. With a historical introduction by Sydney Anglo and a foreword by Sir Anthony Wagner. Oxford: Clarendon Press, 1968.

Grose, Francis. *A Classical Dictionary of the Vulgar Tongue*. 1785. Revised edition, edited by Eric Partridge. London: Routledge and Kegan Paul, 1963.

Holme, Randle. *The Academy of Armory*. Chester, 1688.

Jones, Jonathan. "The Top Ten Codpieces in Art." *The Guardian* online, August 28, 2014.

Leloir, Maurice. *Dictionnaire du costume et de ses accessoires, des armes et des étoffes des origines à nos jours*. 1940. Paris: Gründ, 1951.

Lodge, Thomas. *The Complete Works of Thomas Lodge, 1580–1623?* 1883. Facsimile of the first edition. New York: Russell & Russell, 1963.

Montaigne, Michel de. *Essayes of Montaigne*. Volume II. 1603. Edited by Justin Huntly M'Carthy. Translated by John Florio. Facsimile of the first edition. London, 1889.

Nashe, Thomas. *Have with You to Saffron-Walden*. London, 1596.

Norris, Herbert. *Tudor Costume and Fashion*. Mineola, NY: Dover, 1997.

Phillips, Edward. *The Mysteries of Love & Eloquence*. Third Edition, with Additions. London, 1685.

The Purefoy Letters, 1735–1753. Edited by L. G. Mitchell. London: Sidgwick & Jackson, 1973.

Rabelais, François. *Gargantua and Pantagruel*. 1653. Translated by Sir Thomas Urquhart. London, 1898.

Reynolds, Anna. *In Fine Style: The Art of Tudor and Stuart Fashion*. Exhibition catalogue. London: Royal Collection Trust, 2013.

Ribeiro, Aileen. *Dress and Morality*. Oxford: Berg, 2003.

Schwarz, Matthäus. *The First Book of Fashion: The Book of Clothes of Matthäus and Veit Konrad Schwarz of Augsburg.* Edited by Ulinka Rublack and Maria Hayward. London: Bloomsbury Academic, 2015.

Shakespeare, William. *William Shakespeare: The Complete Works.* Edited by Peter Alexander. London: Random House, 1951.

Squire, Geoffrey. *Dress and Society, 1560–1970.* New York: Viking, 1974.

Stubbes, Philip. *The Anatomie of Abuses.* 1583. London, 1836.

Vincent, Susan J. *The Anatomy of Fashion: Dressing the Body from the Renaissance to Today.* Oxford: Berg, 2009.

Von Boehn, Max. *Modes and Manners.* Translated by John Joshua. London: George C. Harrap, 1932.

The Women's Petition Against Coffee: Representing to Publick Consideration the Grand Inconveniences Accruing to Their Sex from the Excessive Use of That Drying, Enfeebling Liquor. London, 1674.

MICHAEL GLOVER is a London-based poet and art critic, and poetry editor of *The Tablet*. He has written regularly for *The Economist*, *Financial Times*, *The Independent*, *New Statesman*, and *The Times*. He has also been a London correspondent for *ARTnews*. His latest books include *Great Works: Encounters with Art* (2016), *Hypothetical May Morning* (2018), *Late Days* (2018), *The Book of Extremities* (2019), and *Neo Rauch* (2019).

THE *EKPHRASIS* SERIES

"Ekphrasis" is traditionally defined as the literary representation of a work of visual art. One of the oldest forms of writing, it originated in ancient Greece, where it referred to the practice and skill of presenting artworks through vivid, highly detailed accounts. Today, "ekphrasis" is more openly interpreted as one art form, whether it be writing, visual art, music, or film, that is used to define and describe another art form, in order to bring to an audience the experiential and visceral impact of the subject.

The *ekphrasis* series from David Zwirner Books is dedicated to publishing rare, out-of-print, and newly commissioned texts as accessible paperback volumes. It is part of David Zwirner Books's ongoing effort to publish new and surprising pieces of writing on visual culture.

OTHER TITLES IN THE *EKPHRASIS* SERIES

On Contemporary Art
César Aira

Ramblings of a Wannabe Painter
Paul Gauguin

Visions and Ecstasies
H.D.

Pissing Figures 1280–2014
Jean-Claude Lebensztejn

The Psychology of an Art Writer
Vernon Lee

Degas and His Model
Alice Michel

28 Paradises
Patrick Modiano and Dominique Zehrfuss

Summoning Pearl Harbor
Alexander Nemerov

Chardin and Rembrandt
Marcel Proust

Letters to a Young Painter
Rainer Maria Rilke

Giotto and His Works in Padua
John Ruskin

Duchamp's Last Day
Donald Shambroom

FORTHCOMING IN 2020

A Balthus Notebook
Guy Davenport

Two Cities
Cynthia Zarin

Photography

Great care has been taken to credit all images correctly. In cases of errors or omissions, please contact the publisher so that corrections can be made in future editions.

Thrust
A Spasmodic Pictorial History
of the Codpiece in Art
Michael Glover

Published by
David Zwirner Books
529 West 20th Street, 2nd Floor
New York, New York 10011
+ 1 212 727 2070
davidzwirnerbooks.com

Managing Director: Doro Globus
Editor: Lucas Zwirner
Project Manager: Elizabeth Gordon
Proofreader: Chris Peterson

Design: Michael Dyer / Remake
Production Manager: Jules Thomson
Production Assistant:
Elizabeth Koehler
Color Separations: VeronaLibri,
Verona
Printing: VeronaLibri, Verona

Typeface: Arnhem
Paper: Holmen Book Cream,
80 gsm

Publication © 2019
David Zwirner Books

Text © 2019 Michael Glover

Photography credits appear on
page 90.

Distributed in the United States
and Canada by
Simon & Schuster, Inc.
1230 Avenue of the Americas
New York, New York 10020
simonandschuster.com

Distributed outside the
United States and Canada by
Thames & Hudson, Ltd.
181A High Holborn
London WC1V 7QX
thamesandhudson.com

ISBN 978-1-64423-024-4

Library of Congress
Control Number: 2019911559